CR♥SH+COLOR

JASON MOMOA

**A Coloring Book of Fantasies
With an Epic Dreamboat**

CR♥SH+COLOR

JASON MOMOA

A Coloring Book of Fantasies
With an Epic Dreamboat

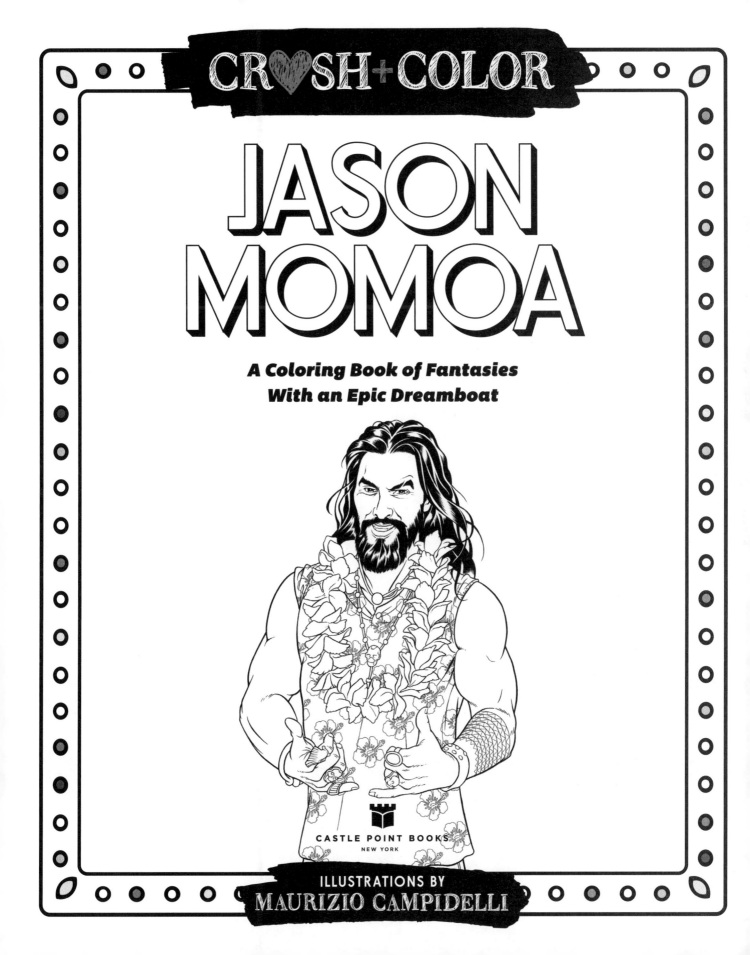

CASTLE POINT BOOKS
NEW YORK

ILLUSTRATIONS BY
MAURIZIO CAMPIDELLI

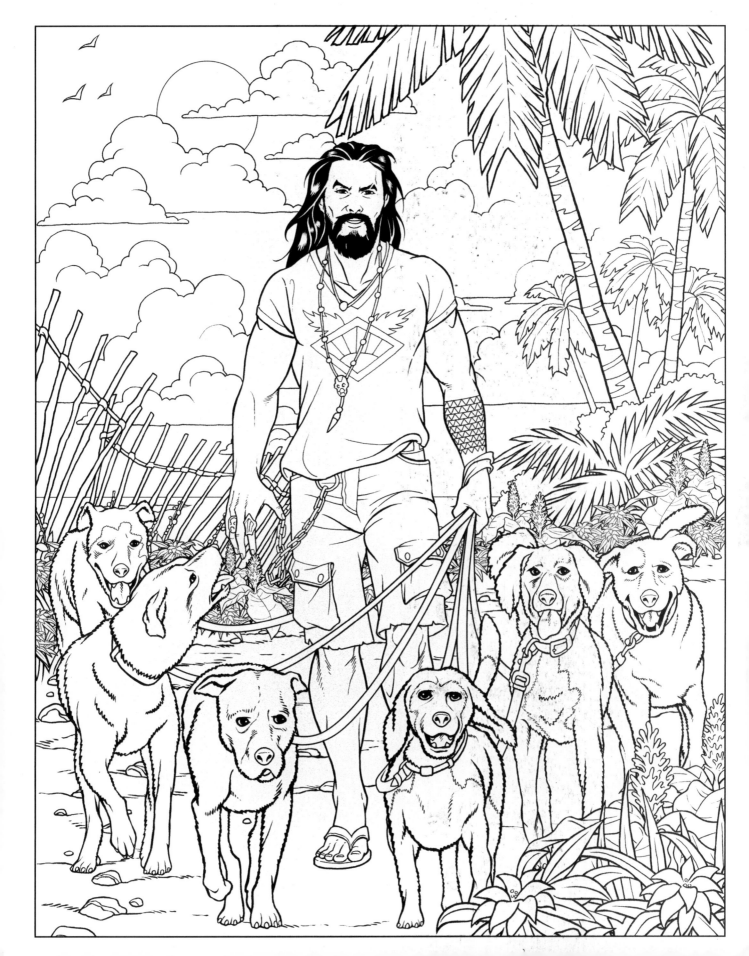

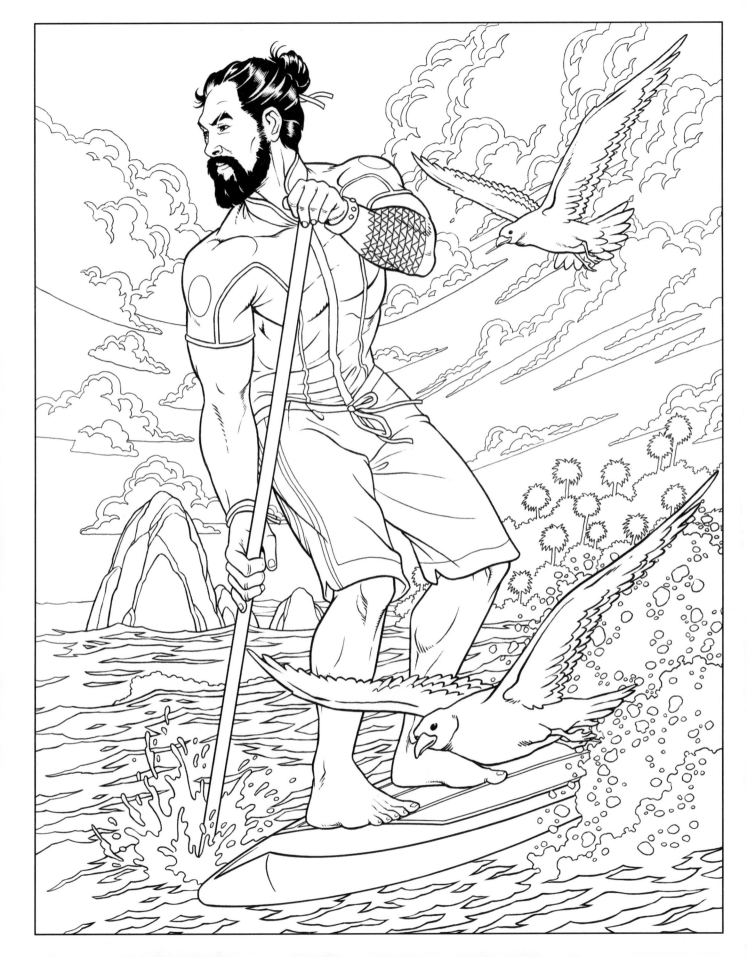

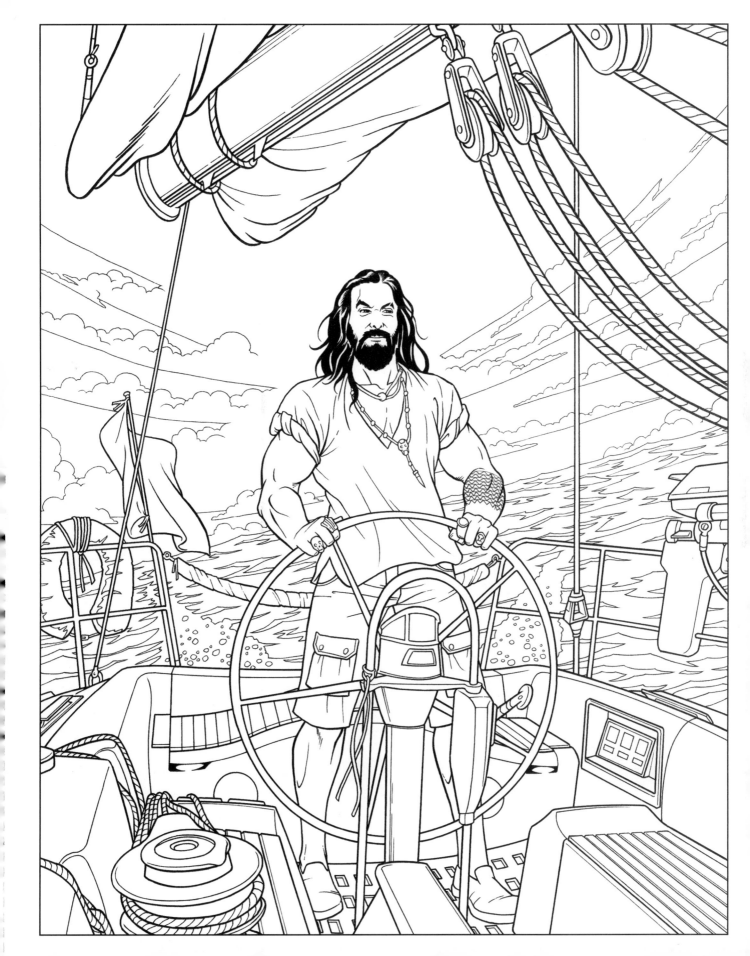

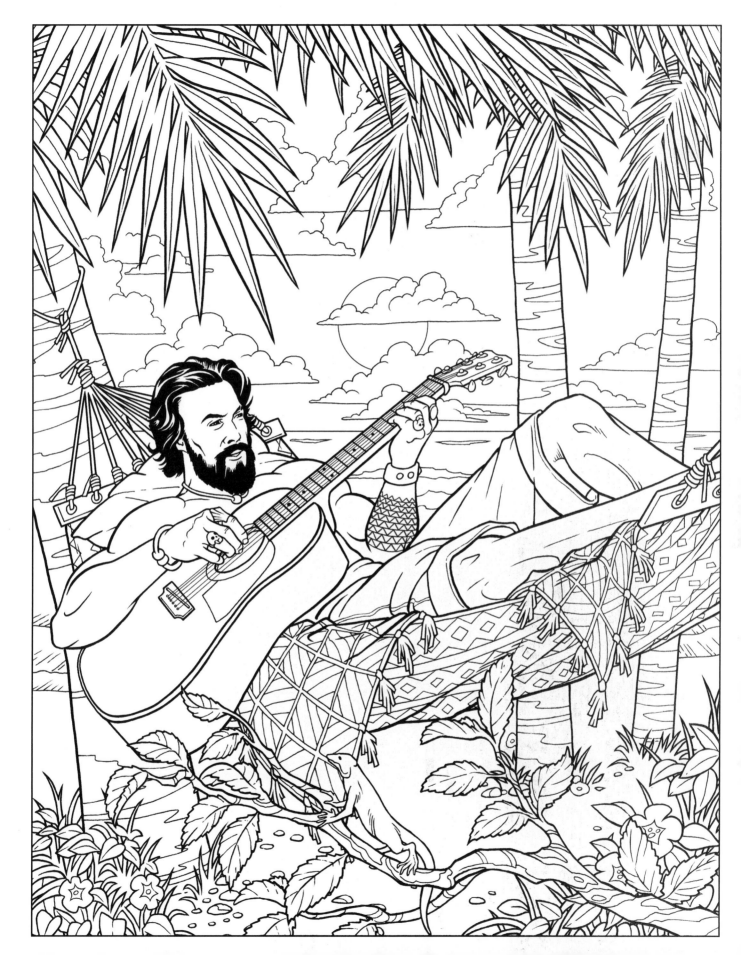

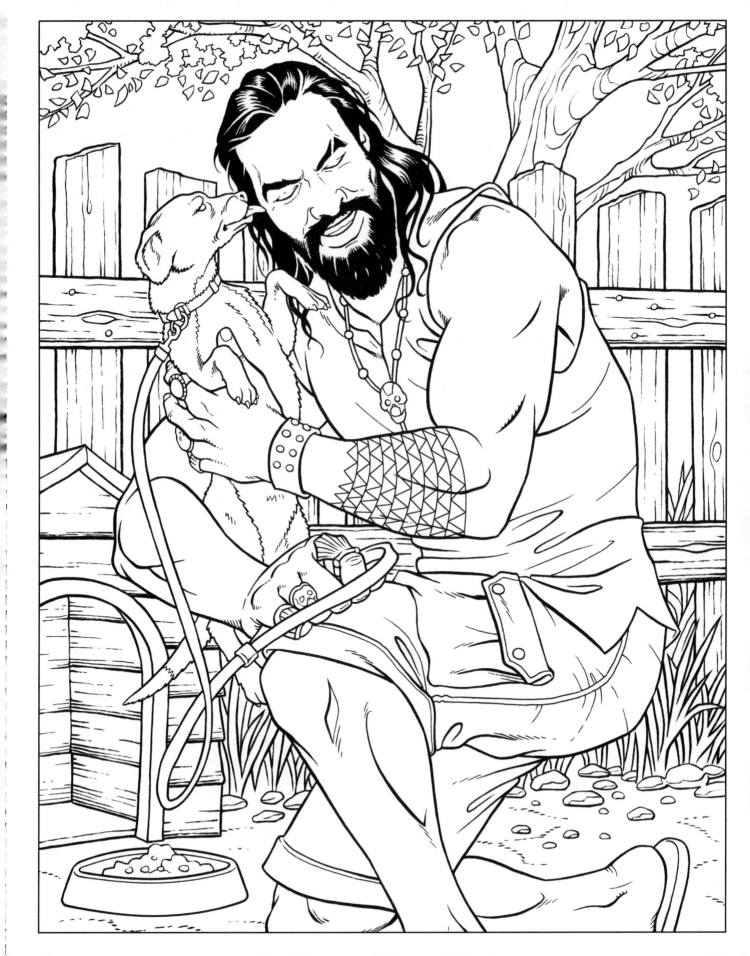

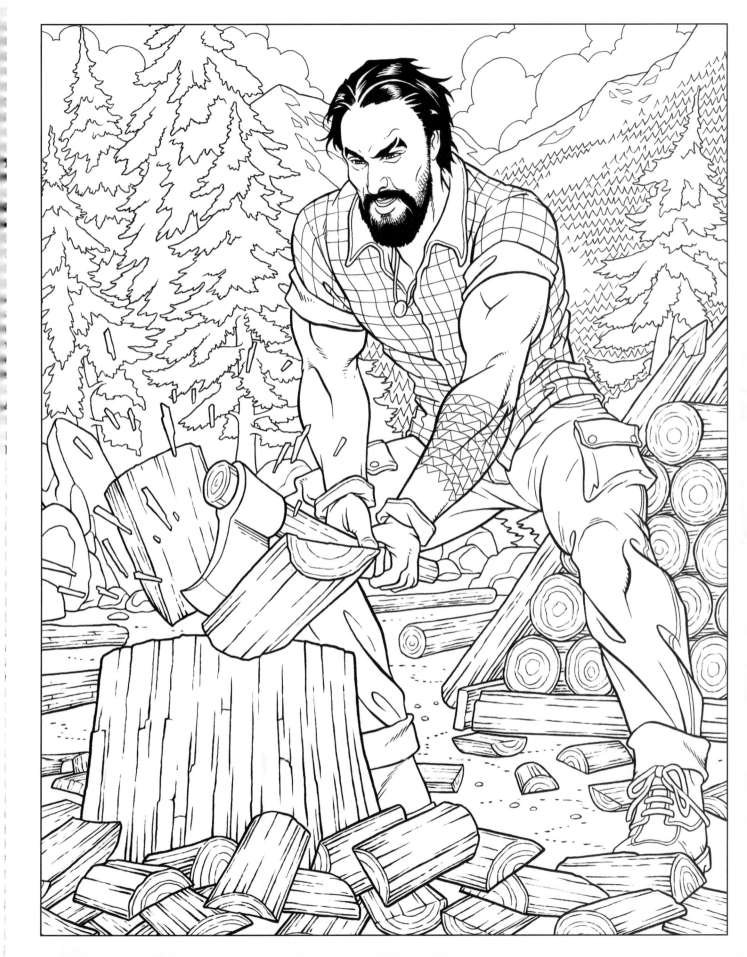

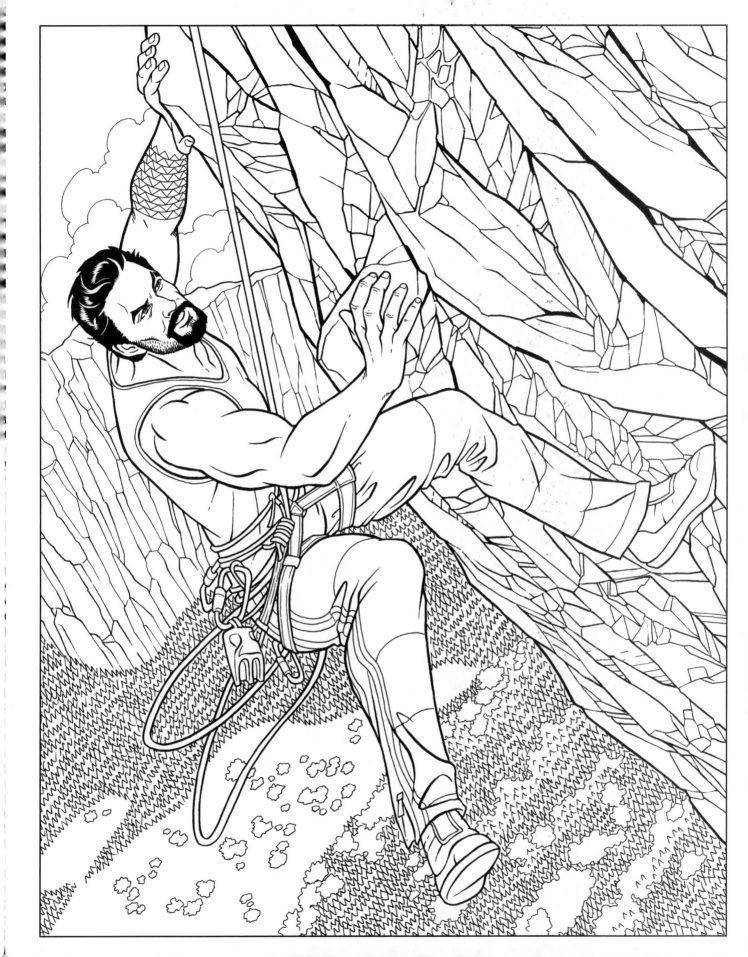

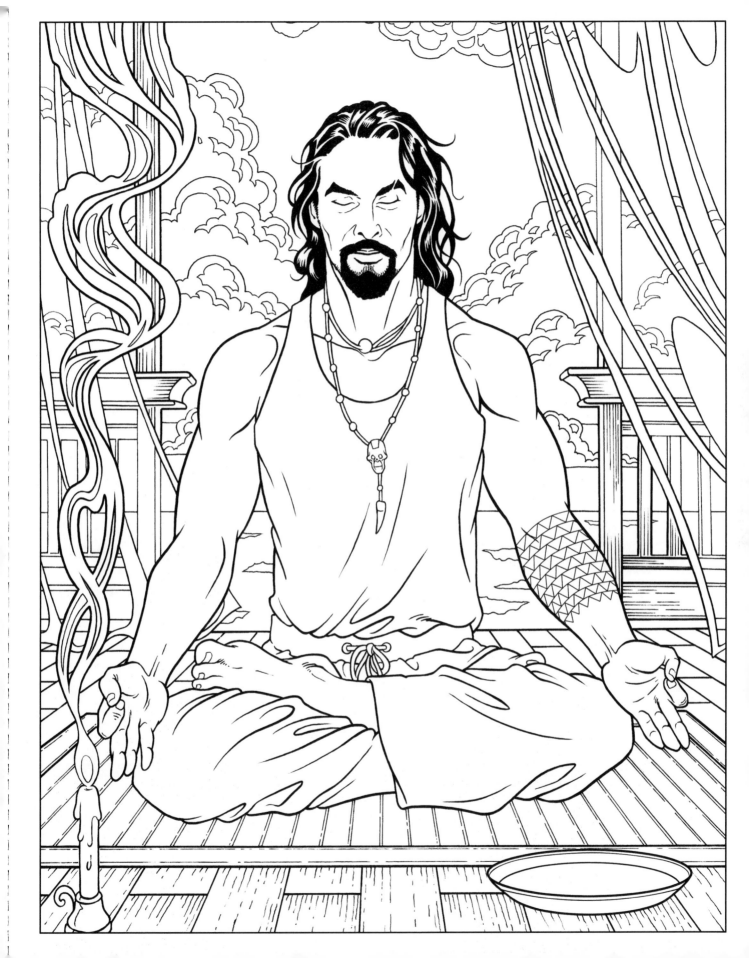

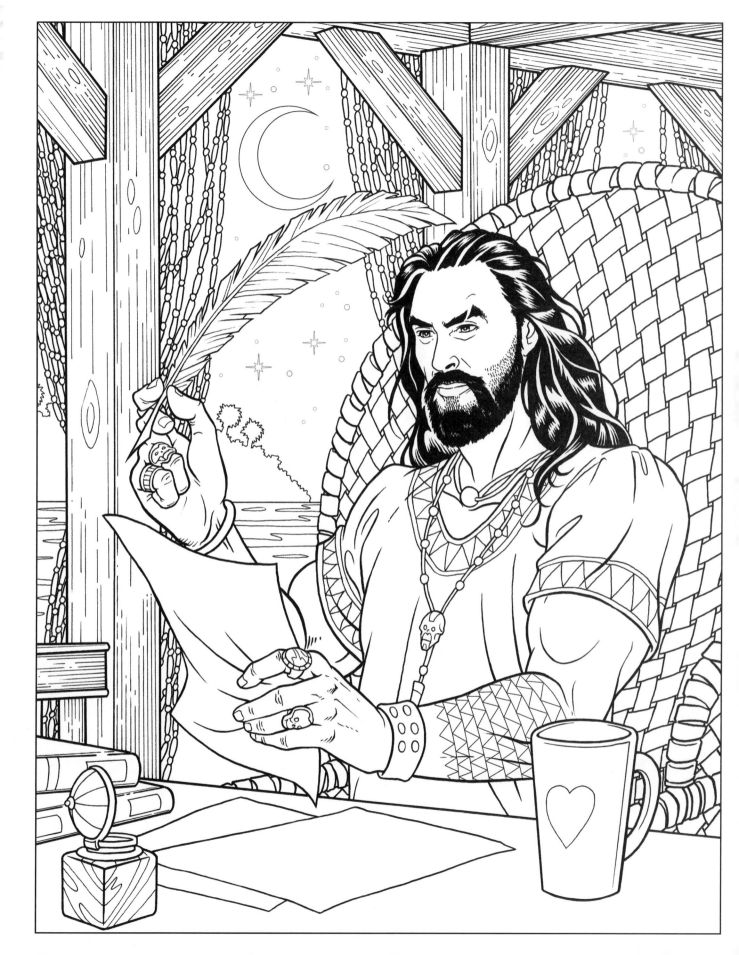

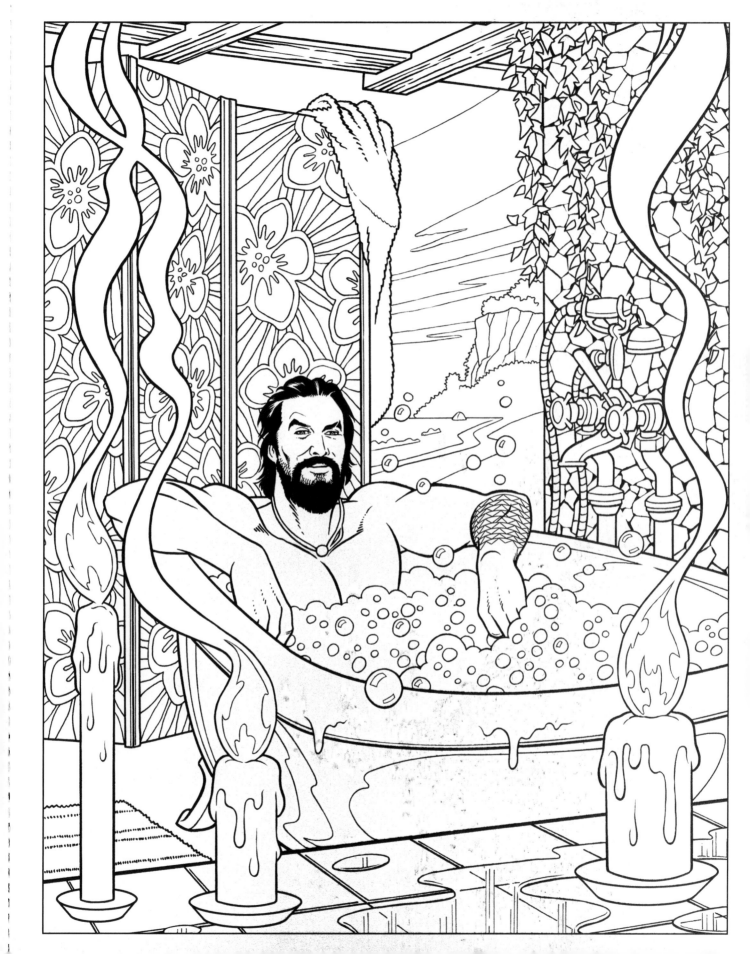

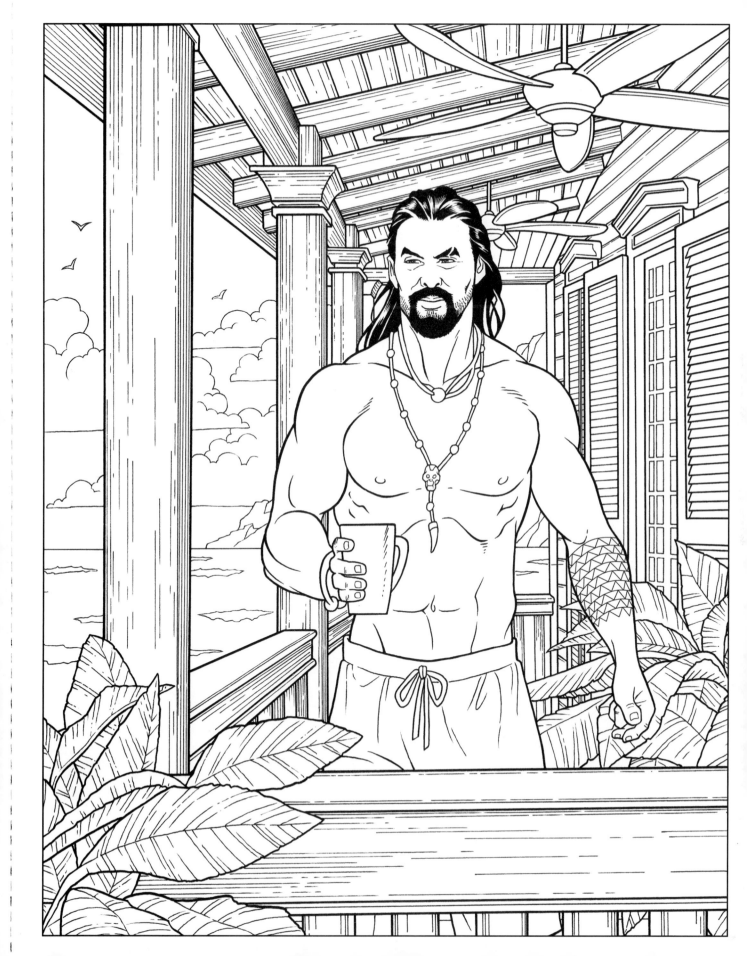

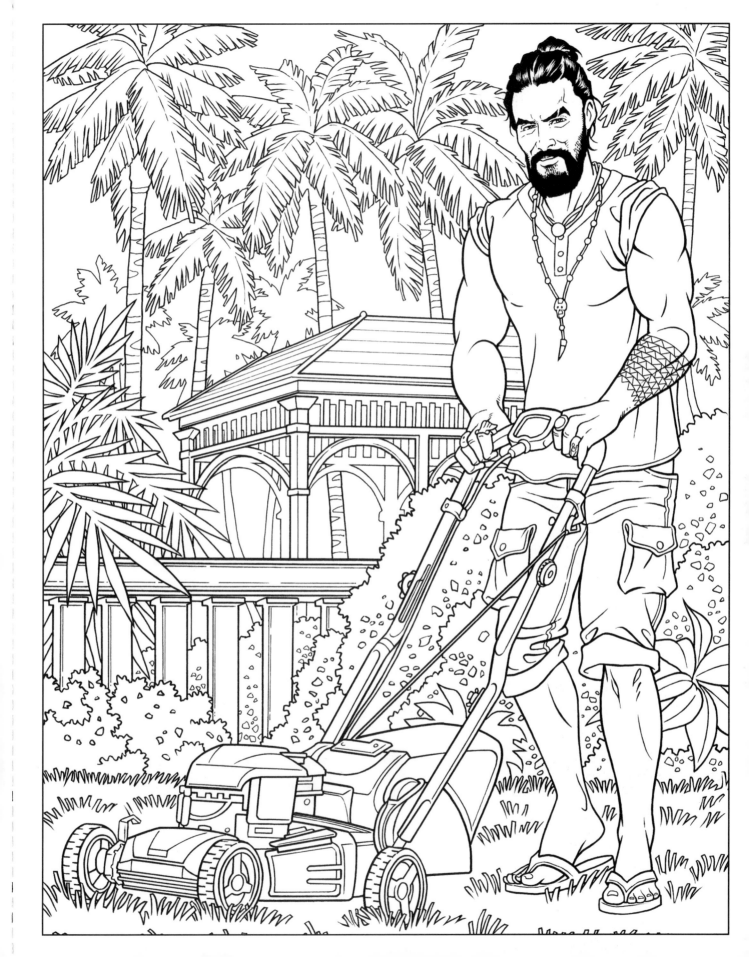

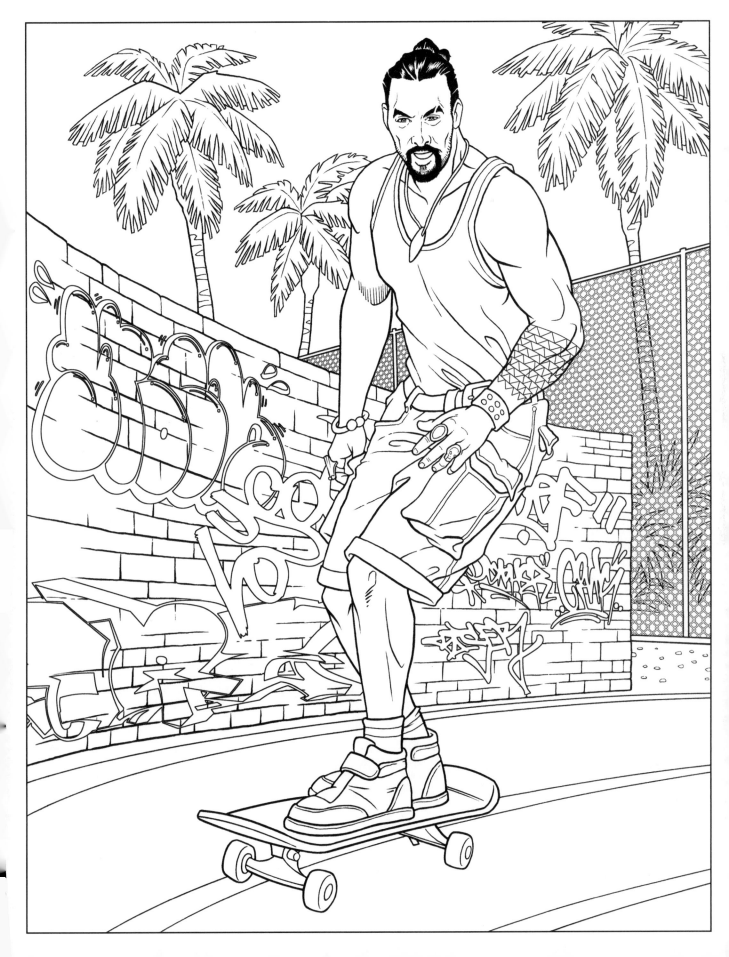

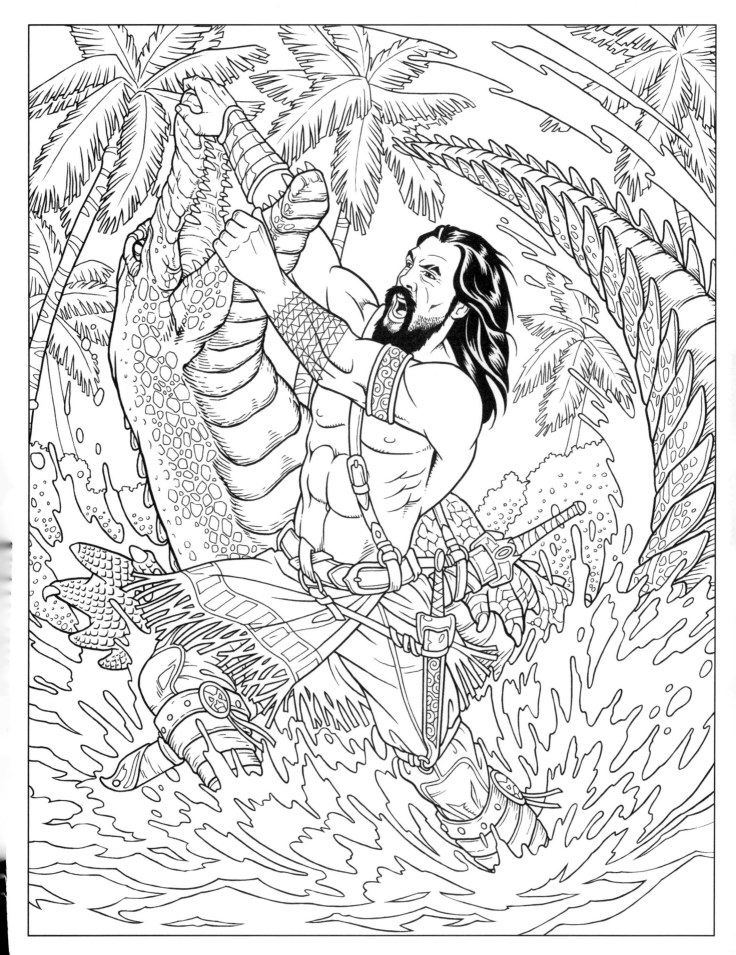

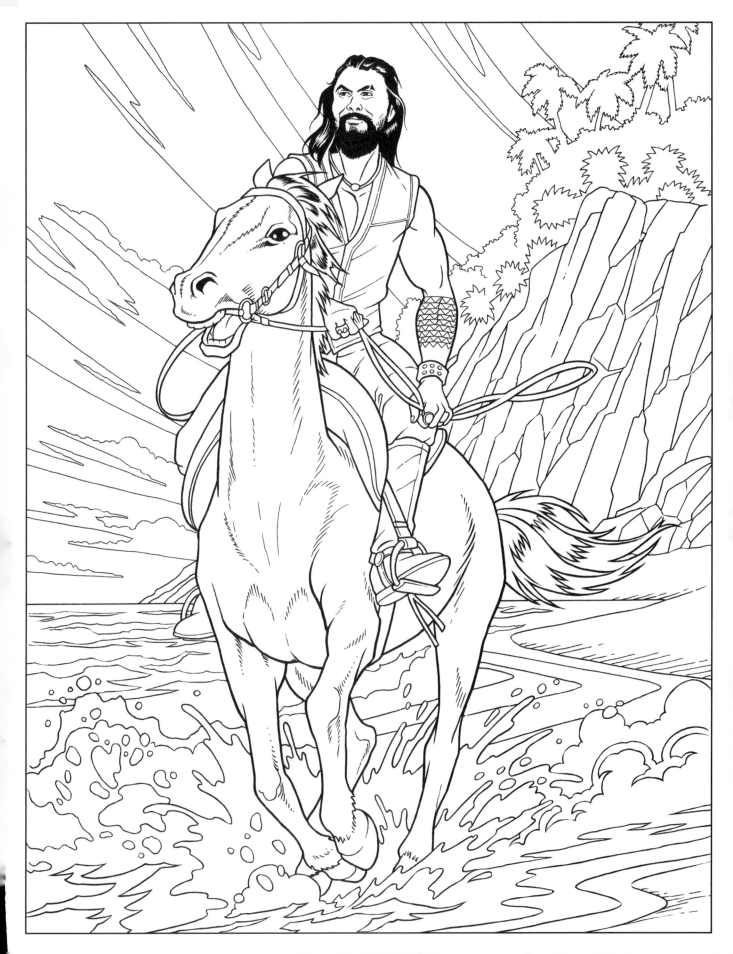

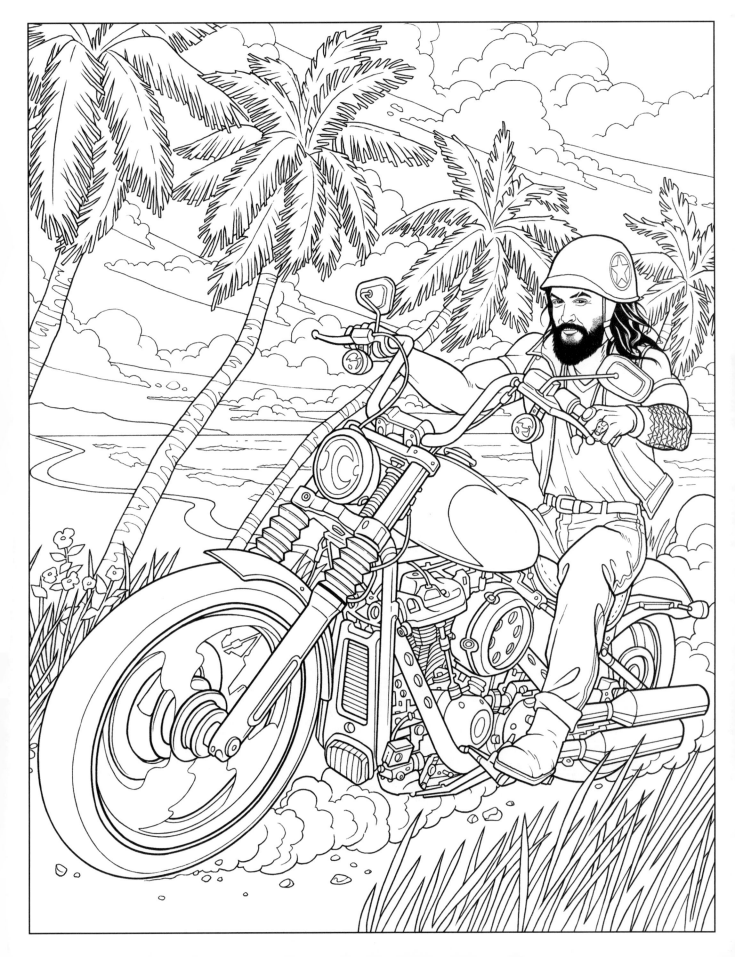

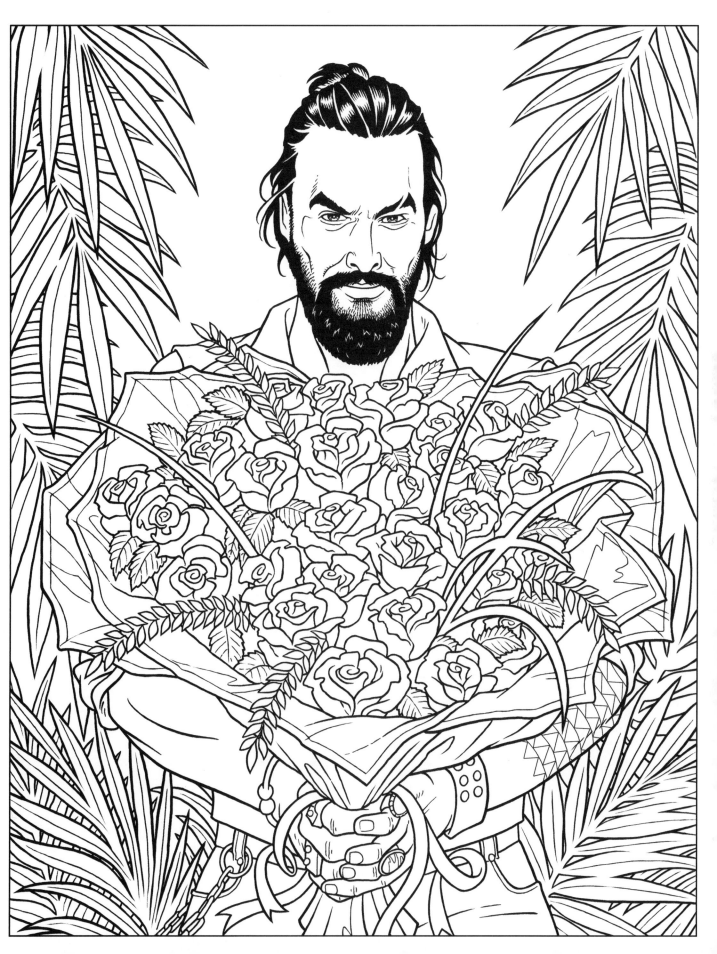

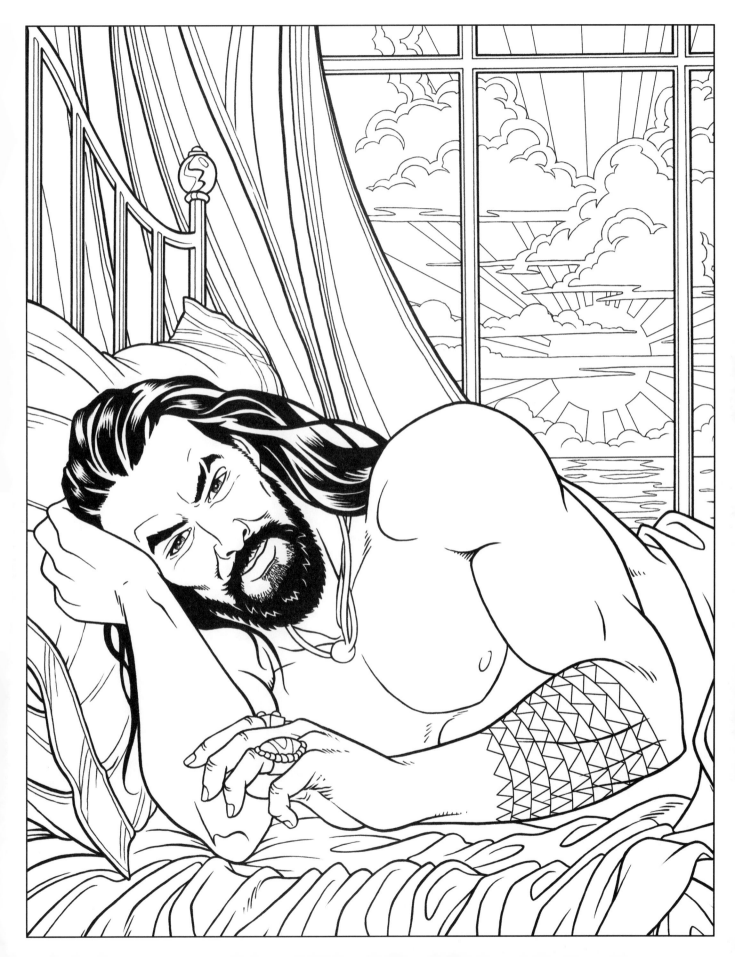

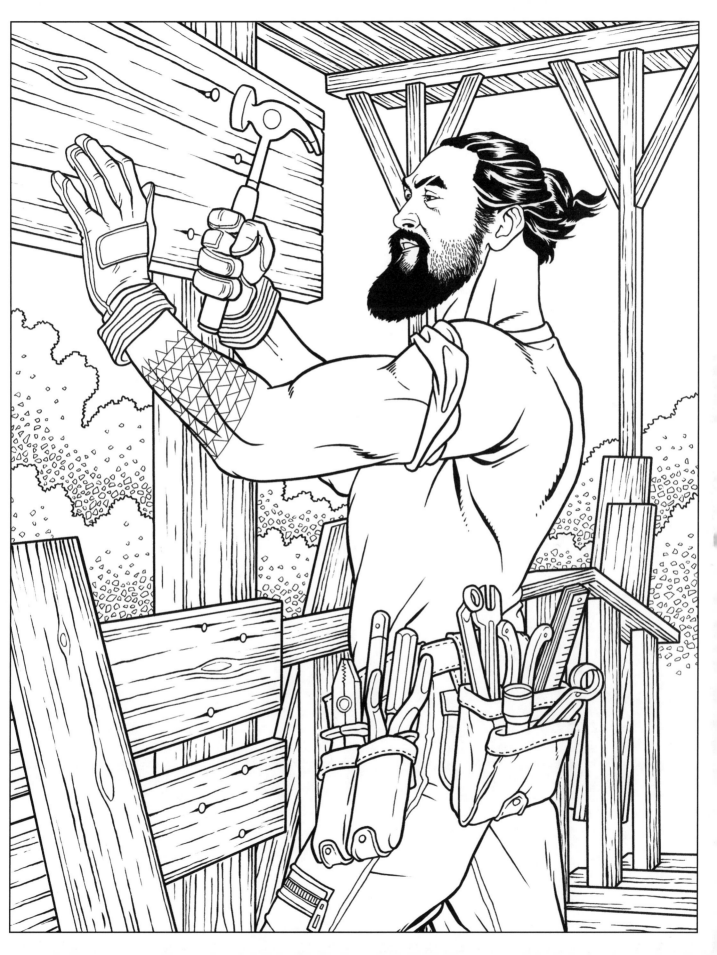

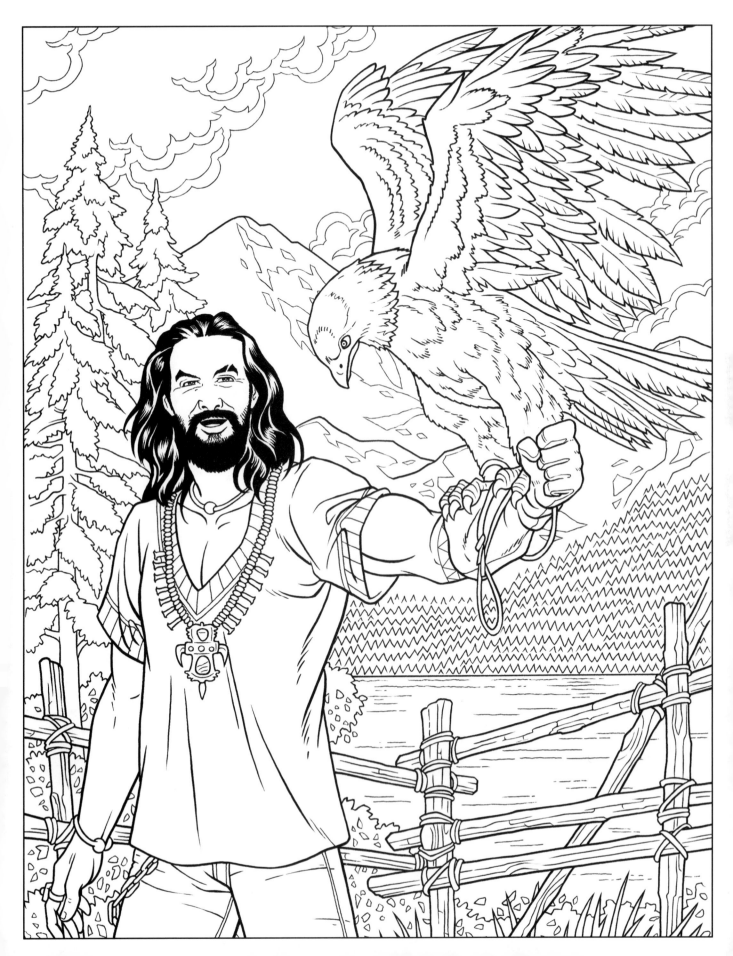

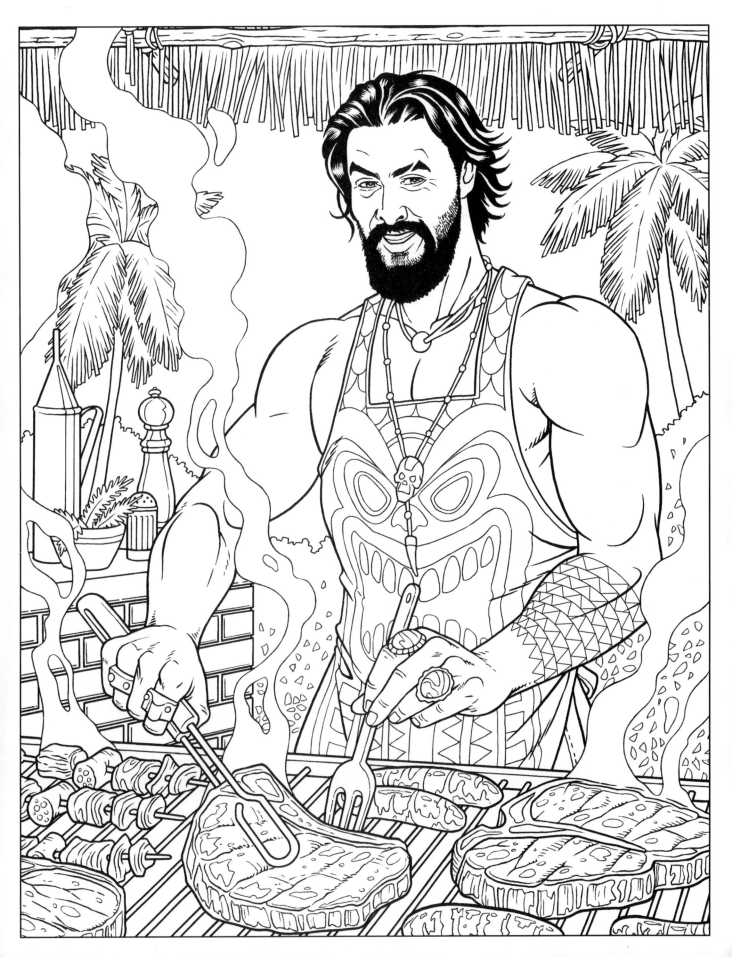

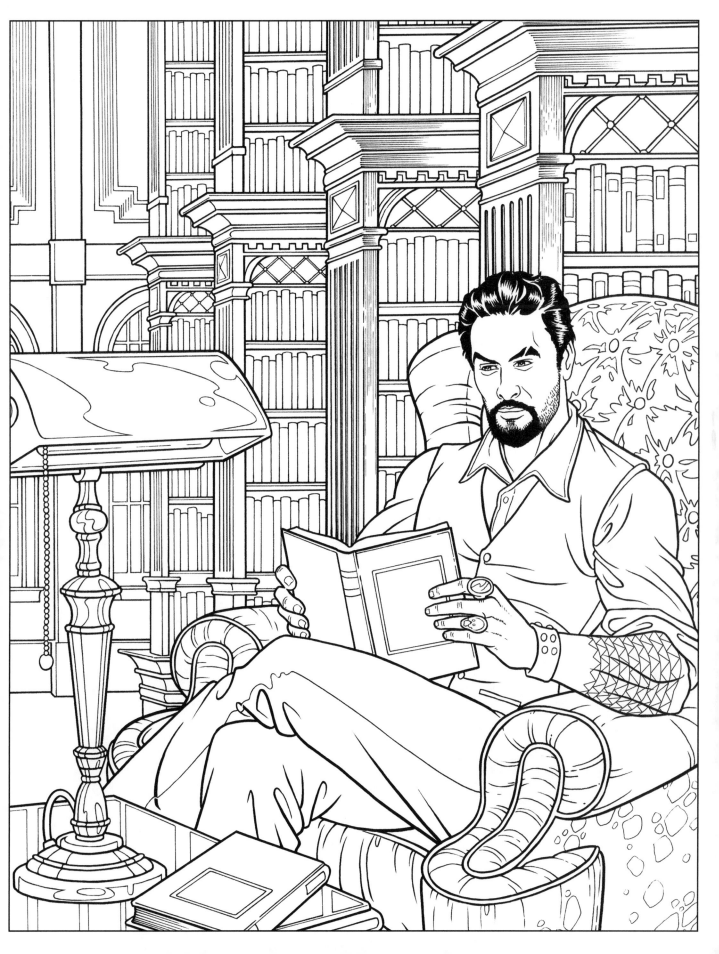

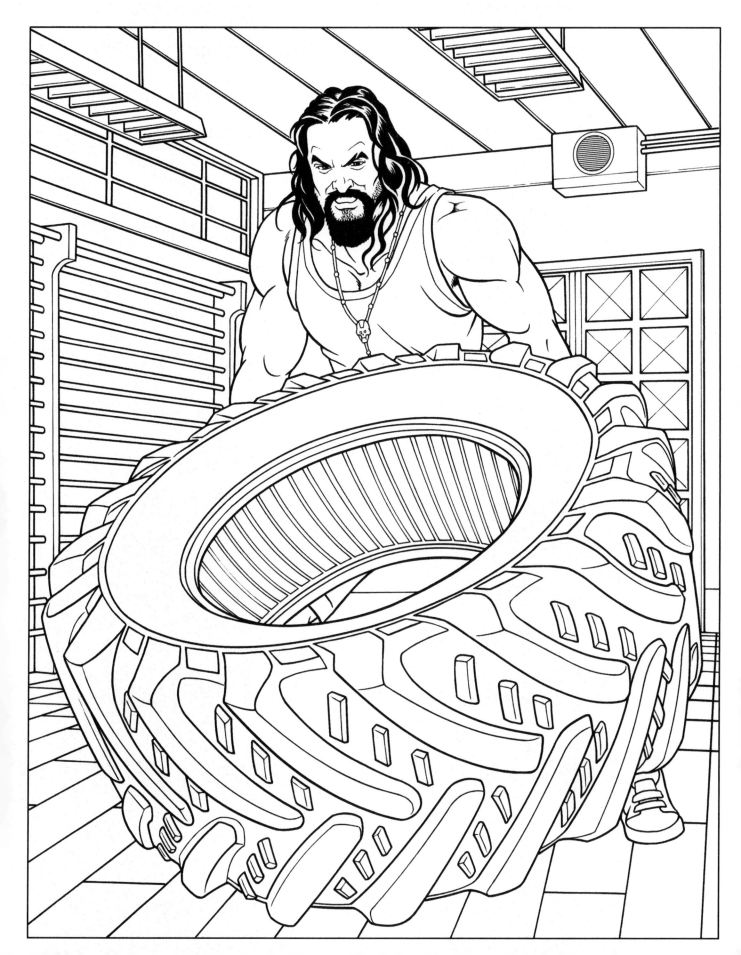

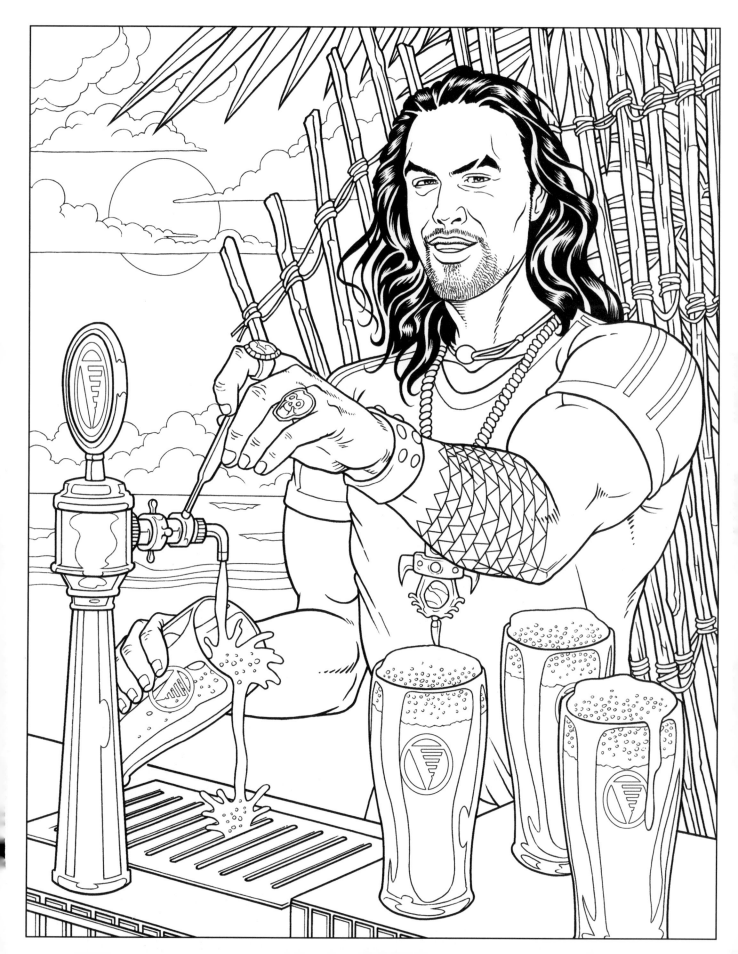

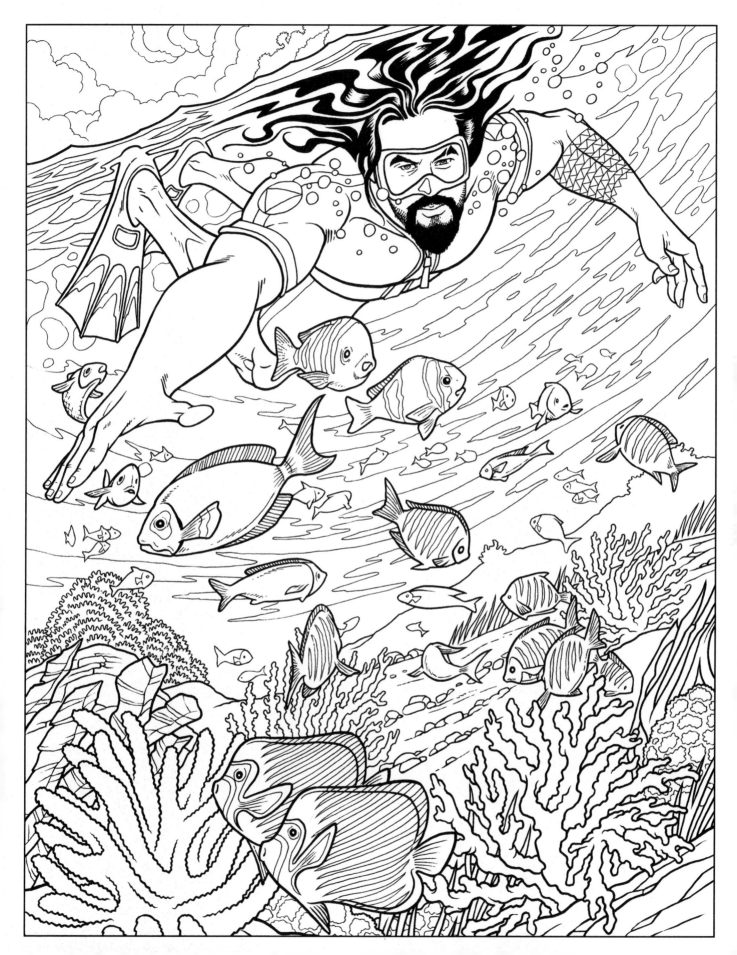

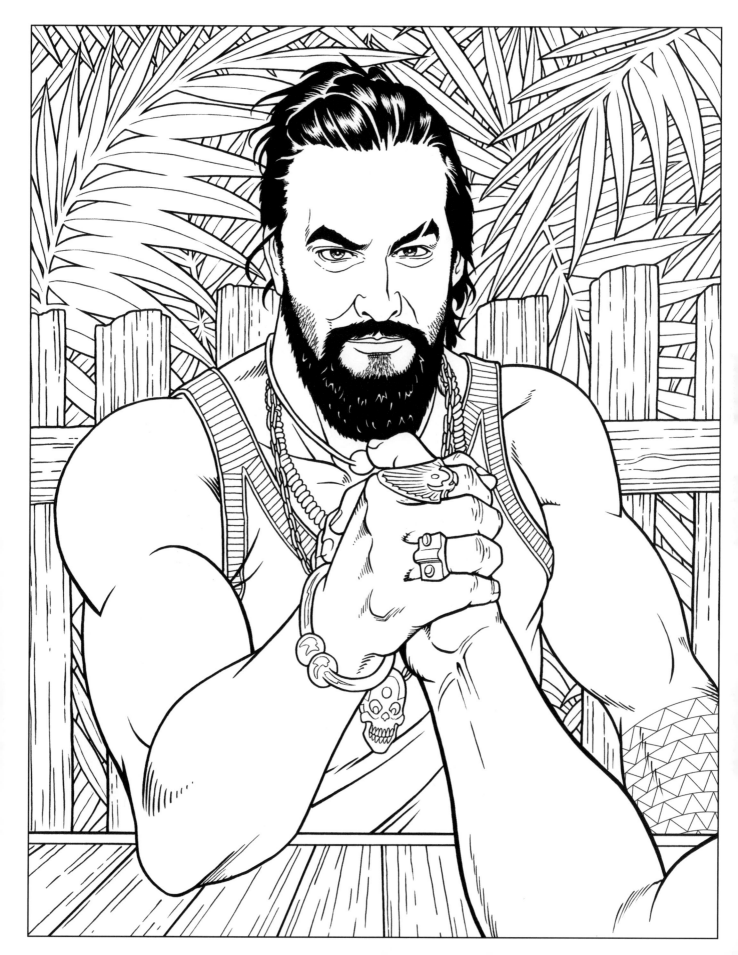

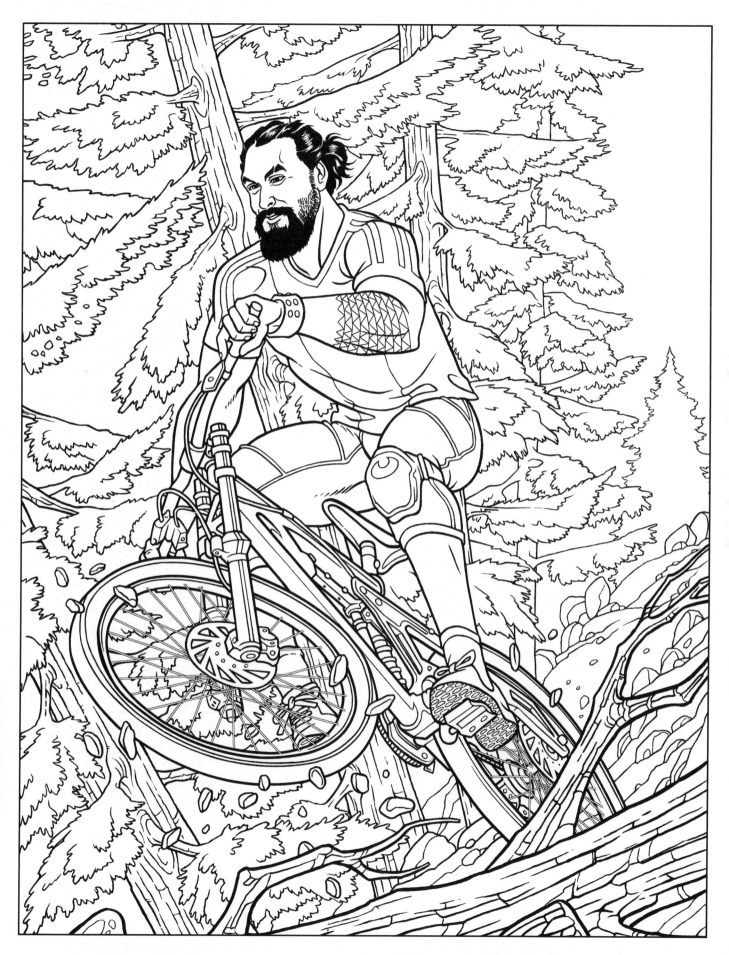

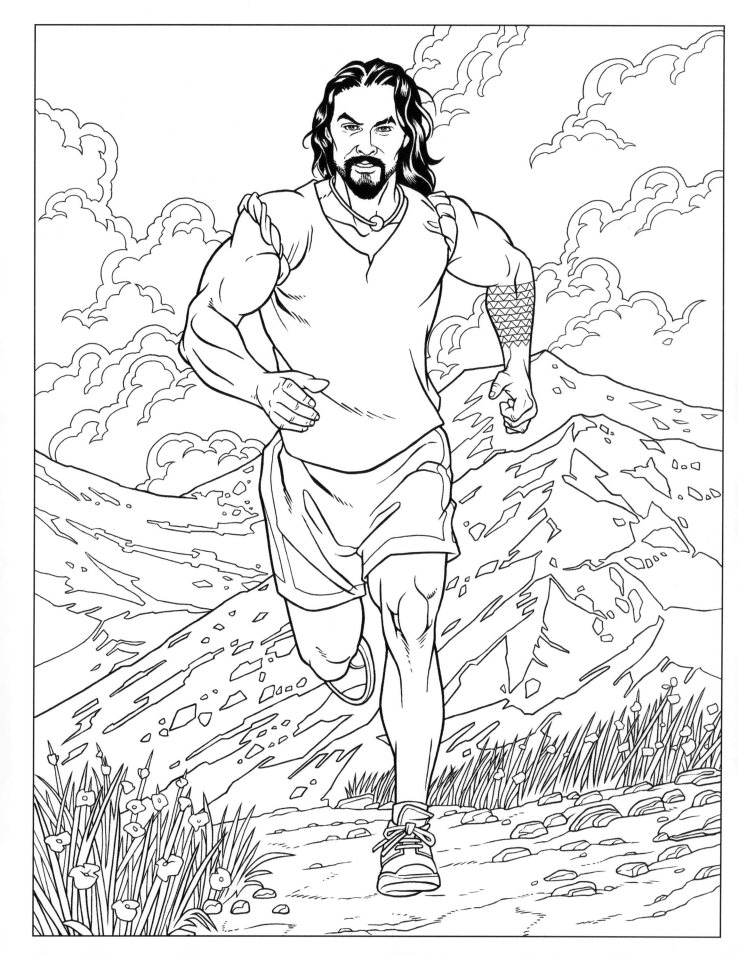

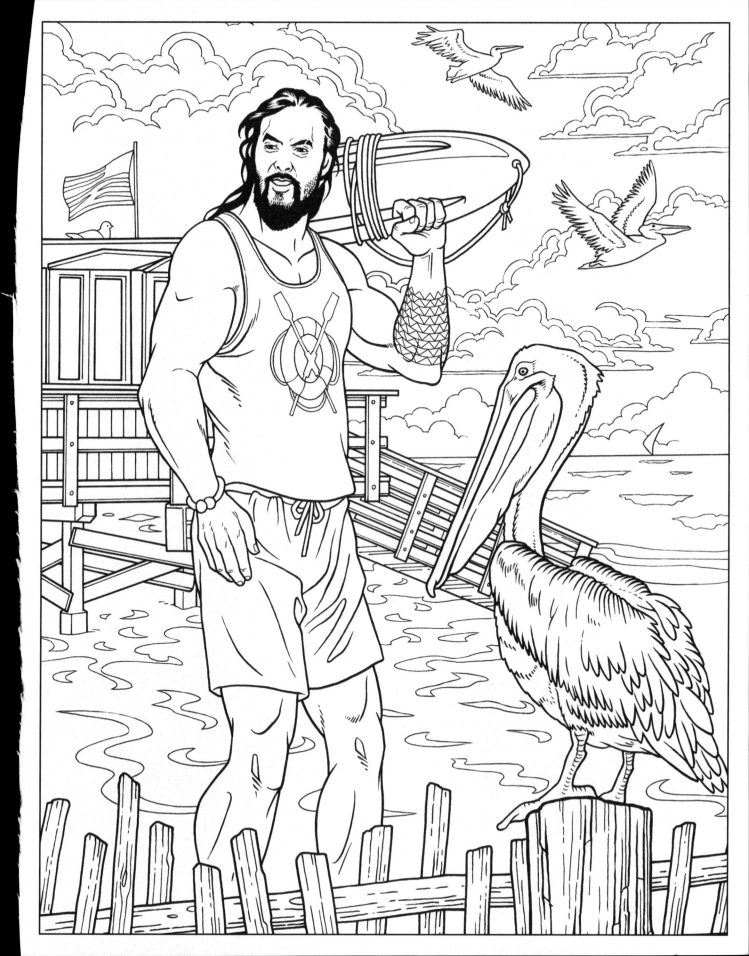

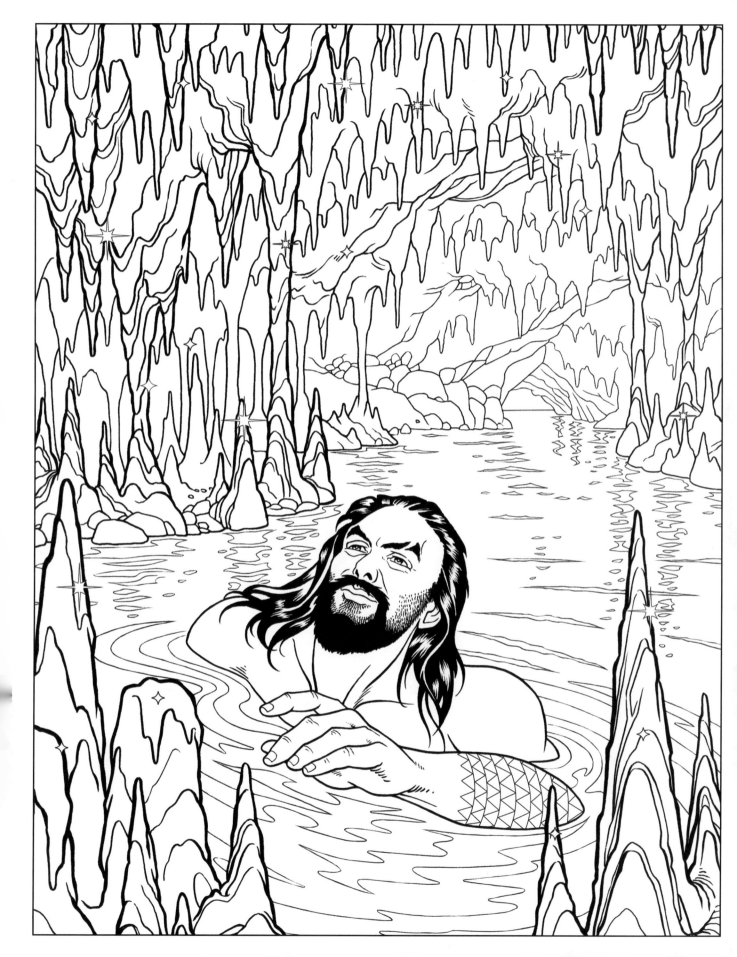

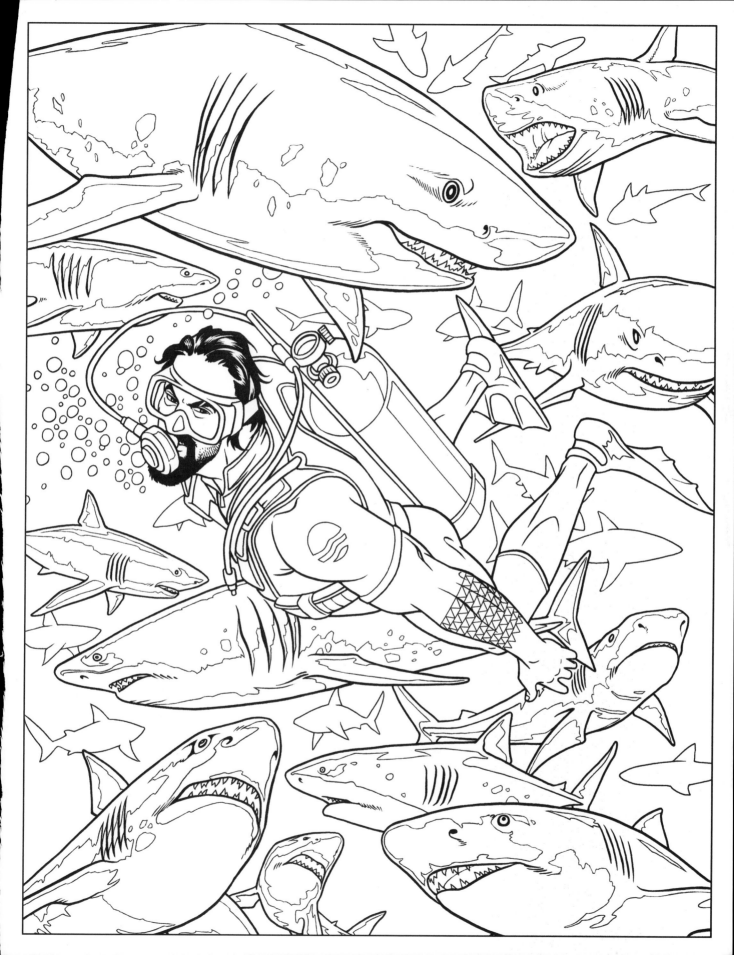

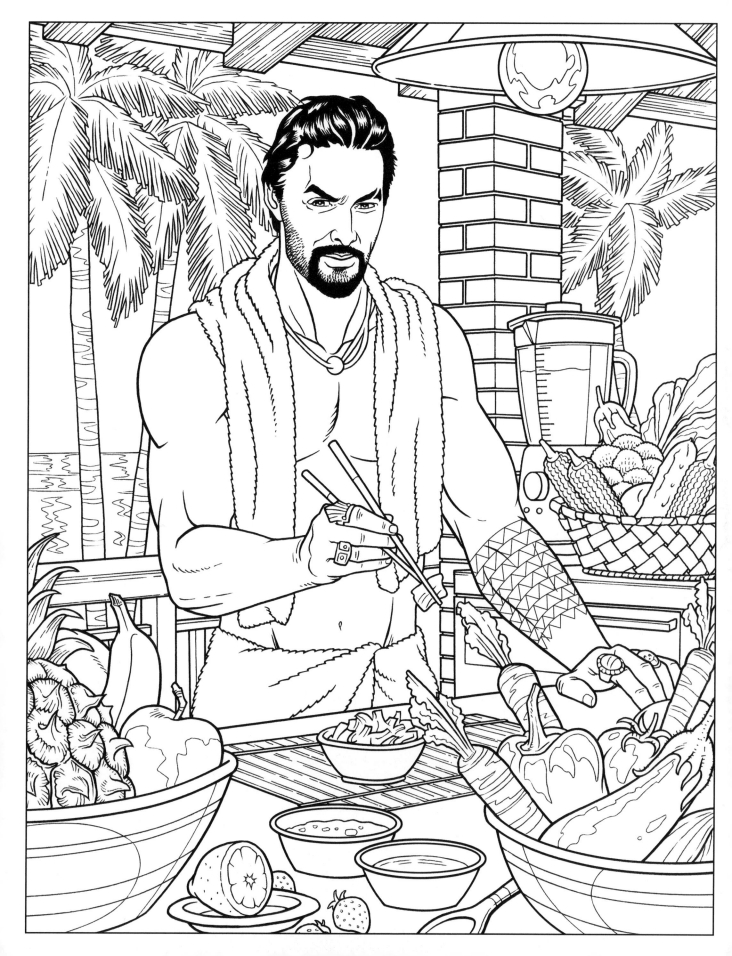

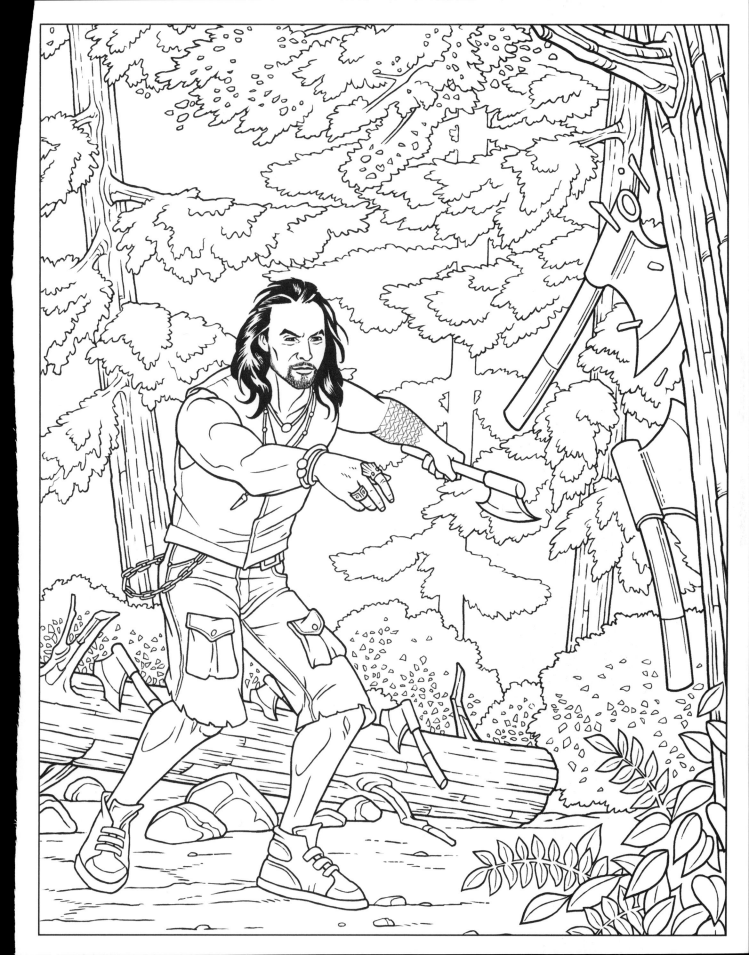

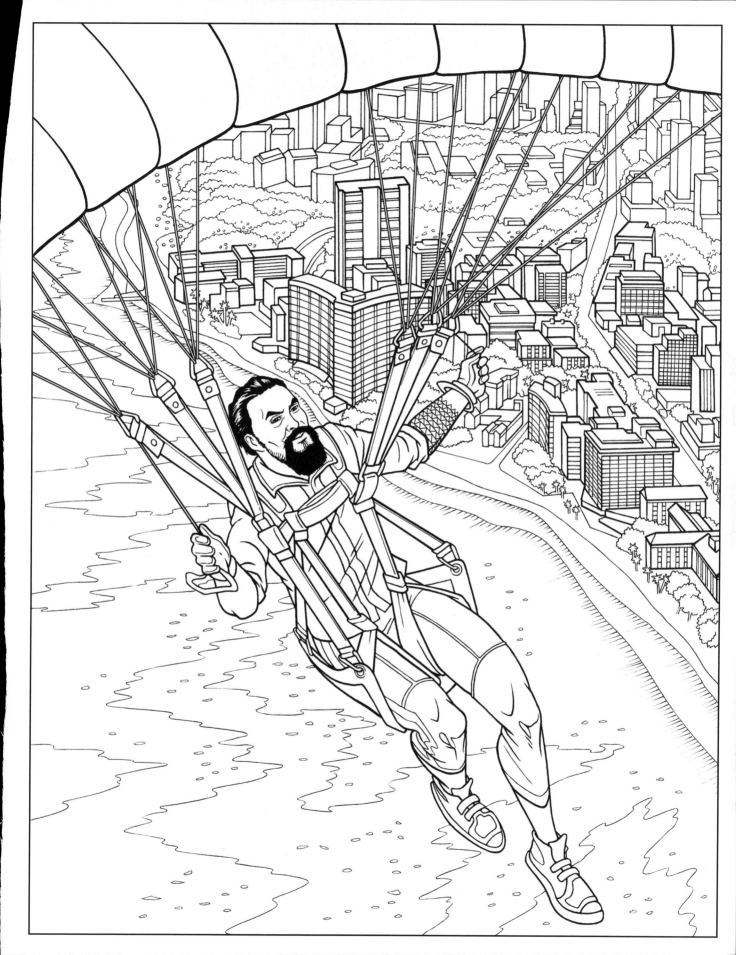

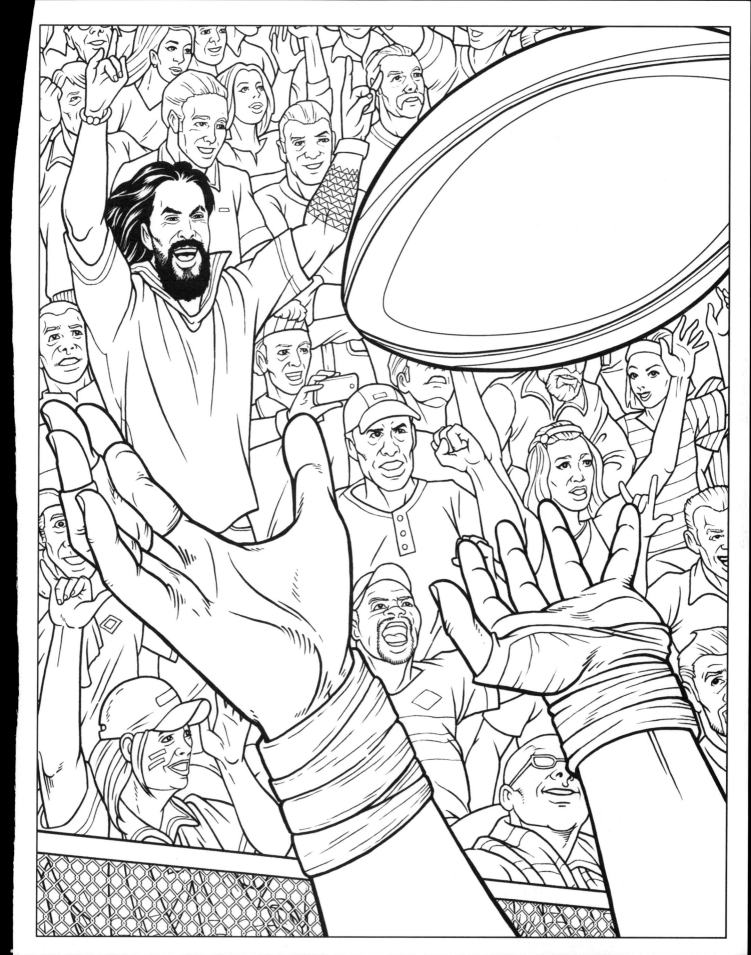

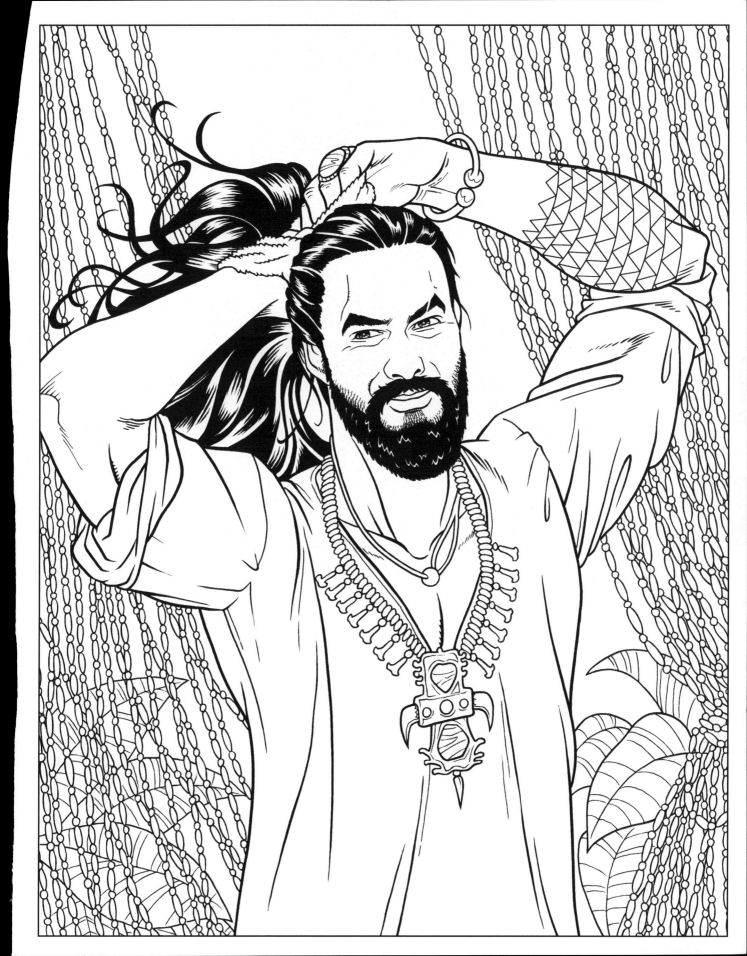

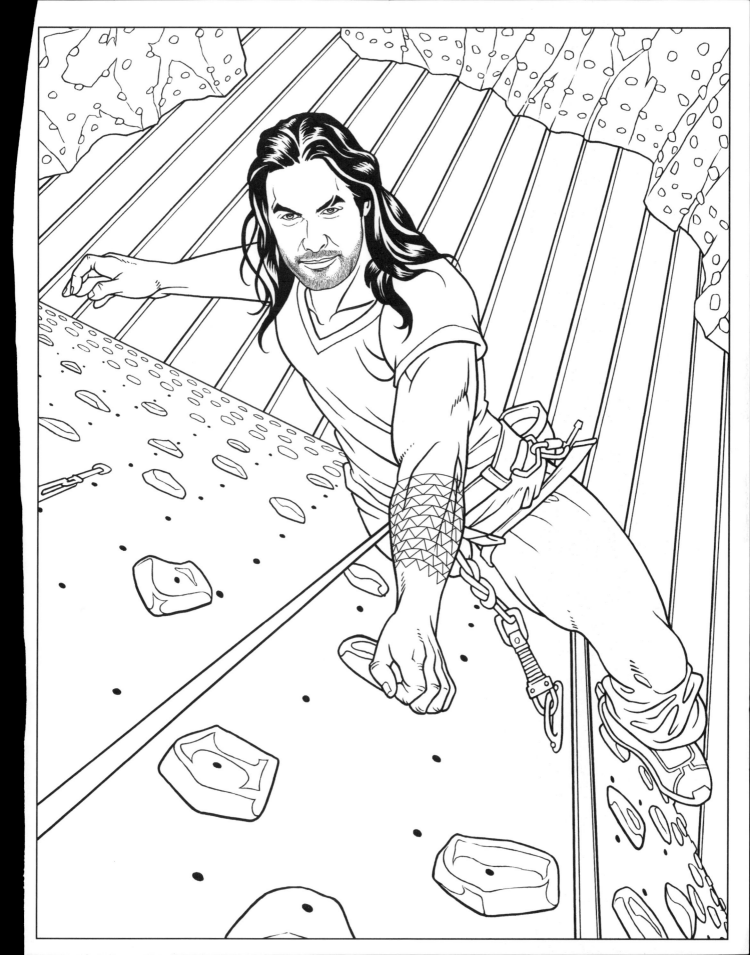

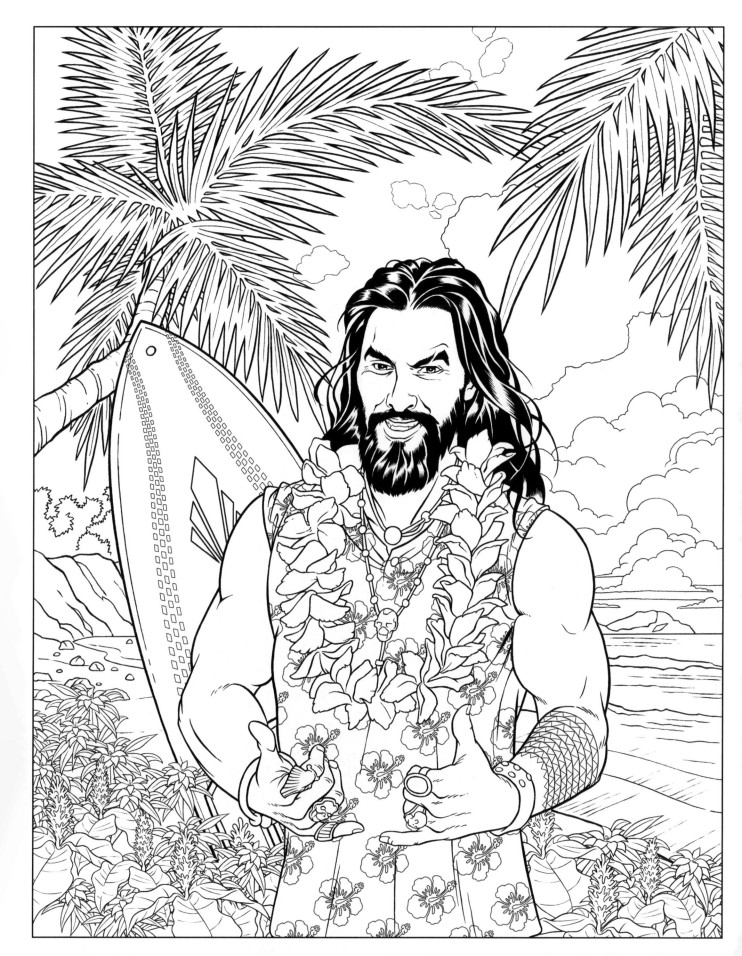